A Book
of Glyphs

For Carol
& Ross

w/ many
good
Memories

E/
11-27-14

A Book of Glyphs

Edward Sanders

Granary Books
New York City 2014

ISBN 978-1-887123-81-5
Printed in the United States of America
Book and cover design by Lotus + Pixel

Granary Books, Inc.
168 Mercer St. Suite 2
New York, NY 10012
www.granarybooks.com

Distributed to the trade by
D.A.P./Distributed Art Publishers
155 Avenue of the Americas, Second Floor
New York, NY 10013-1507
Orders (800) 338-BOOK
Tel. (212) 627-1999 Fax (212) 627-9484
www.artbook.com

Also available from
Small Press Distribution
1341 Seventh Street
Berkeley, CA 94710
Orders (800) 869-7553
www.spdbooks.org

To Miriam and Deirdre,
and our trip to Florence

A Book of Glyphs

THE GLYPH HAS ALWAYS been of great
importance to me. For me, a Glyph is a drawing
that is charged with literary, emotional, historical
or mythic and poetic intensity. When I was
young I was stunned by the Zen rock garden at
the Nelson Art Gallery in Kansas City. The rock
gardens of Kyoto, when I studied them later in
books, seemed like living hieroglyphs. After I
came to New York City in 1958, I again was
stunned by the Egyptian art at the Metropolitan
Museum. The hieroglyphs on the tomb walls and
in the papyri also seemed almost alive.

When I was in jail writing *Poem from Jail* in the
summer of 1961, after attempting to swim out

and board a Polaris Submarine as an anti-war protest, I drew Egyptiana hieroglyphic study cards, with the hieroglyph on one side, and the English translation on the back. Later, in the fall of 1961, I studied Egyptian at the New School, and one evening I read John Cage's *Silence*, in which the line breaks and the placing of multiple columns of lines on the same page seemed "glyphic." After that, my poetic life was never the same. The Glyph—visual elements in poetry—came to mean what Matisse was seeking when he sat in his wheel chair with long bladed scissors cutting the paper shapes for his cut-outs. I began using Glyphs in my poetry, starting in 1962 up to the present.

In late September of 2008, I flew to Italy with Miriam and our daughter Deirdre where I read poetry and stayed a few days at the Torre Guelfa in downtown Florence, near the Ponte Vecchio. It was a great joy walking at ease and at leisure around Florence and up and down the streets adjacent to the Arno River. At a small store on

the Left Wing side of the River which featured hand-made paper goods, I purchased a beautiful small notebook on September 28, and then went down the street to the Casa de Popolo, a workers café, where I began drawing Glyphs into the notebook with some colored pencils I had purchased. I titled the notebook, "Smile-Book of Grace-Joy," because my mood during those weeks was happy and upbeat. It was an ebullient time, being a presidential year in the United States, and it appeared as if the liberal candidate was going to win.

Miriam, Deirdre and I spent a few days just walking around the city, visiting the Duomo and great museums, marveling at the bustling good vibes, art, architecture and statuary. All in all, it seemed that many things were Looking Good, as they say. During this, I carried my new *Book of Glyphs* with me, and the colored pencils, and drew regularly till all 72 pages in the book were filled with Glyphs.

Inspired by all this work in Glyphs, back in Woodstock I spent weeks organizing my life's work in literary drawings, sequencing them into a number of archival boxes in my archive. Included in one box was *A Book of Glyphs* begun at the Casa de Popolo in Florence. There it resided till four years later, in the fall of 2012, when Steve Clay spotted it while reading through my boxes of Glyphs, and soon offered, to my gratitude, to publish it in a facsimile edition.

> — Edward Sanders
> Woodstock, New York

A Book
of Glyphs

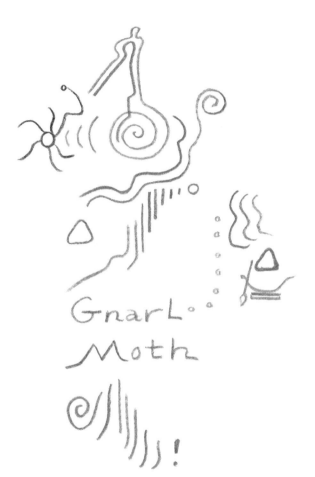

Gnarl
Moth

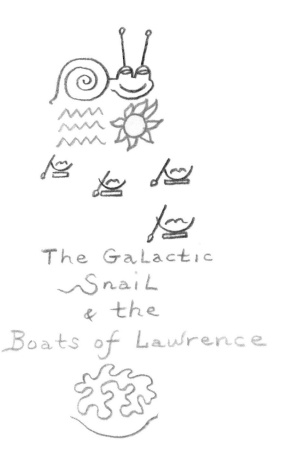

The Galactic Snail
& the
Boats of Lawrence

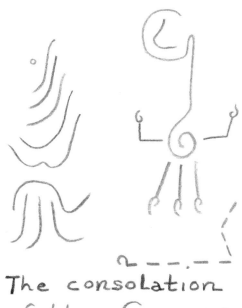

The consolation
of the Curves

The O Factor

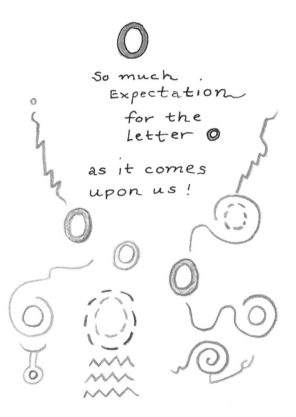

So much
Expectation
for the
Letter O

as it comes
upon us!

Gratefulness

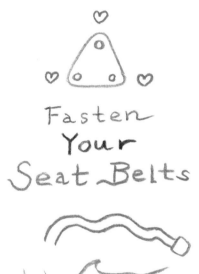

Fasten Your Seat Belts

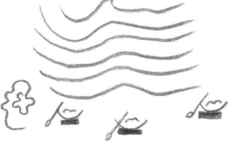

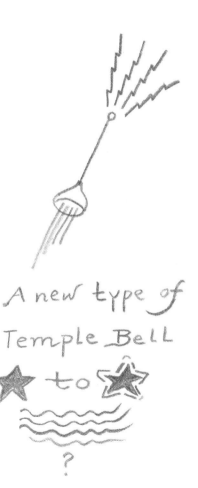

A new type of

Temple Bell

★ to ★

?

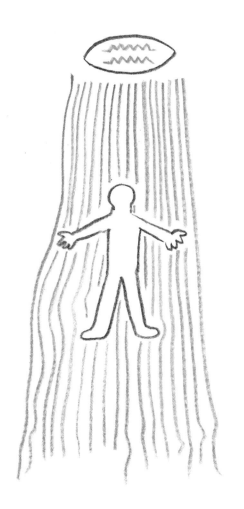

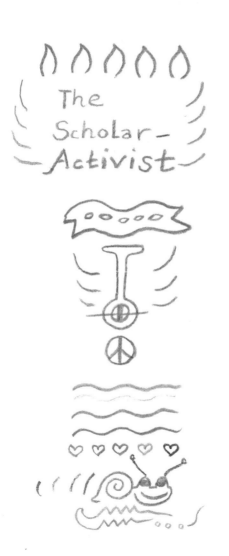

The Scholar-
Activist

A Time of Hope

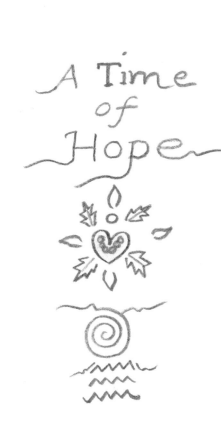

Some are happy in a quiet room
Weaving maps with Clio's Loom
Some are satisfied w/ graph and List
but not the Scholar–Activist

The Rose

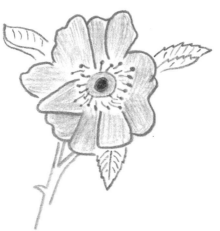

Haunts all of Time ✿

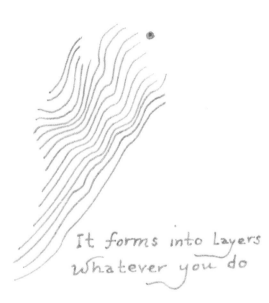

It forms into layers
whatever you do

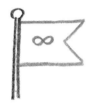

Time Out!
Time Out!

Memories
of DeVere

"You'll go to college
I'll always be a
Laborer"

1956

Roll Roll Roll

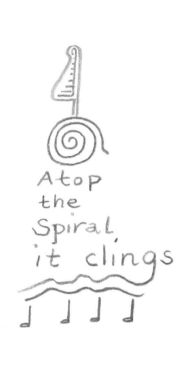

Atop
the
Spiral
it clings

Unable

[mouth illustration in box]

[heart]

fully

to speak

& in the Showers of Gold
o Danaë

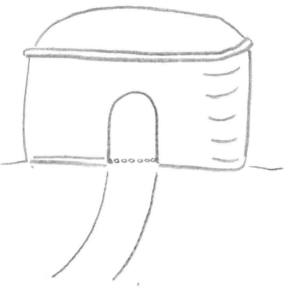

knowing
that the door
is open
is half

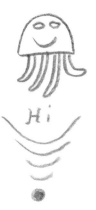

Hi

After the Turmoil
Hi!
Will arrive

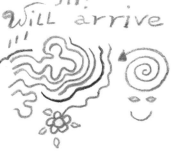

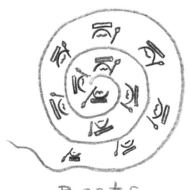

Boats

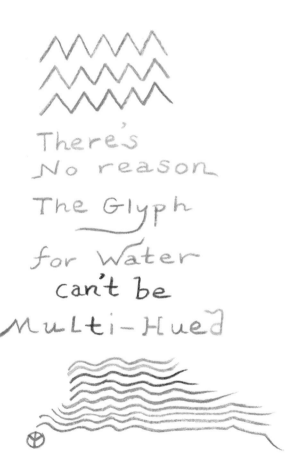

There's
No reason
The Glyph
for Water
can't be
Multi-Hued

Border

The dreamer seeps through the rust

Wars

Collected Poems

Planck Unit

The Eyebrows
of your mentors

always are there

helping you with

the luggage

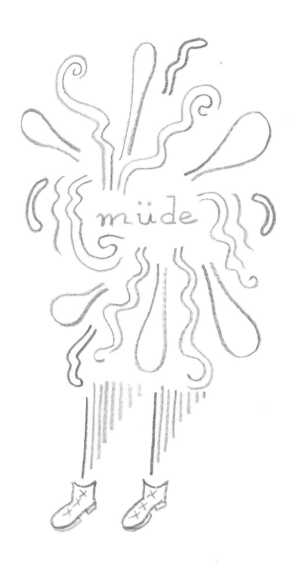

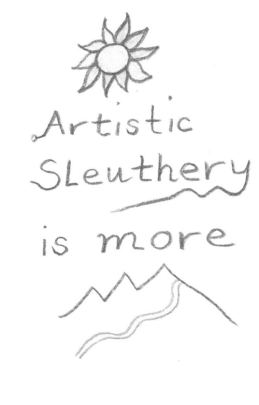

Artistic
Sleuthery
is more

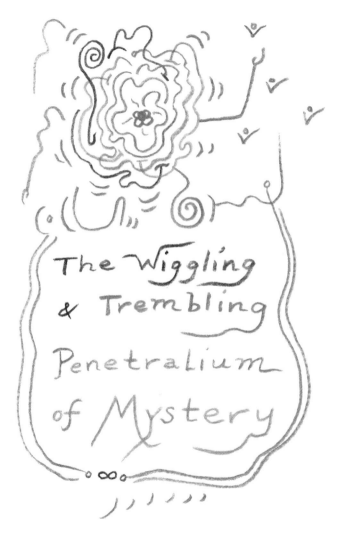

The Wiggling
& Trembling

Penetralium

of Mystery

Some where
in the Fresh Kills
Land fill

is the tambourine
I smashed
in 1965

Please go get it
o Future!

What
is
It ?

Hitch-hiking
Planet ?

Still
enmeshed
by the Myths

Traced by

Aeschylus

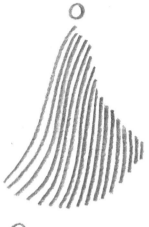

Grace

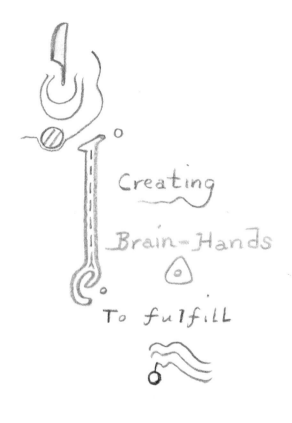

Creating

Brain-Hands

To fulfill

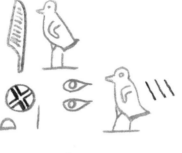

Polis is

Eyes

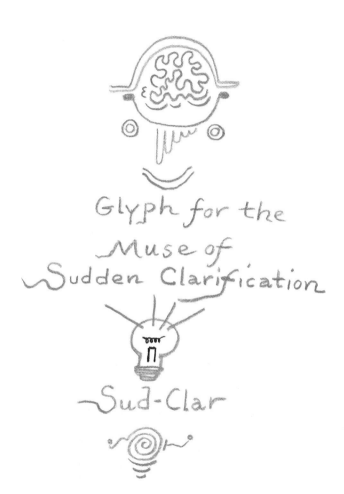

Glyph for the
Muse of
Sudden Clarification

Sud-Clar

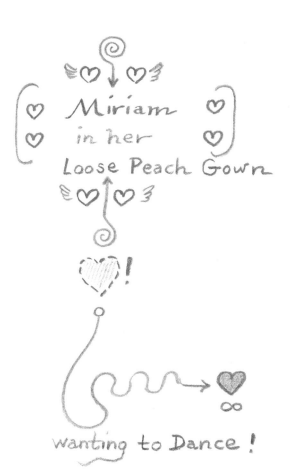

Miriam
in her
Loose Peach Gown

!

wanting to Dance !

Through
The veils & vales
of Forever
I hope to Boat
with you

o Ramamir!

Amidst
the
Flowing Forces

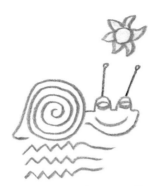

The Snail of
Space-Time
still
somehow
smiling

In the beginning
Not Knowing

In the end
Not Knowing

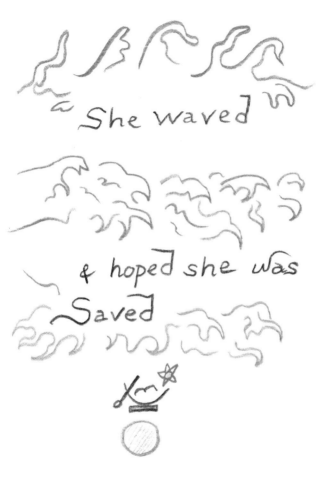

She waved

& hoped she was
Saved

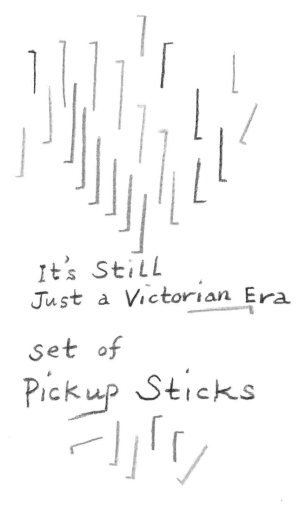

It's still
Just a Victorian Era

set of

Pickup Sticks

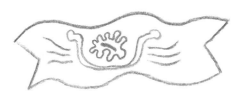

Your Entity
on the Banner
that Beckett
spoke about
in Enueg I

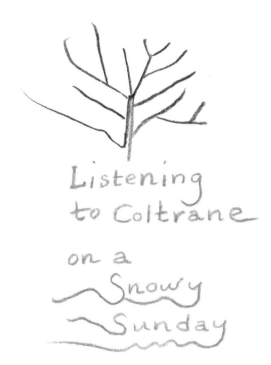

Listening
to Coltrane

on a
Snowy
Sunday

Let's not
keep fighting

The Trojan War

Achilles'
Axe

(crawling
cluster
bomb)

OK ?

Help- Hands

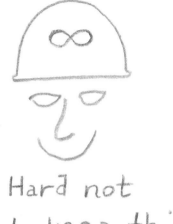

Hard not
to keep thinking

about it

Don't for**get**

hori z on ality

✱ Van Gogh's crows

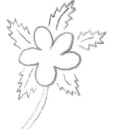

Reading
"Prolegomenon
to any Future
Metaphysics"

on a construction
site
 in 1958

Particles —
each one could

Theoretically

hold a Universe

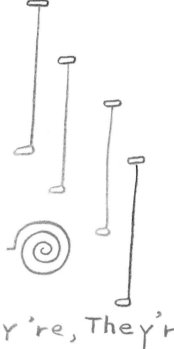

They're, They're
THERE

A Blue River of Ideas

from the Penetralium

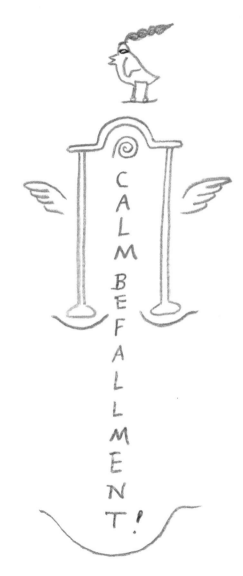

CALM BEFALLMENT!

ἐν ᾗ ἀρχή

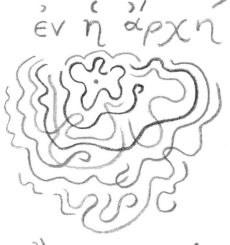

ἦν τὸ Μικρότατον ?

i.e.

Planck Unit ?

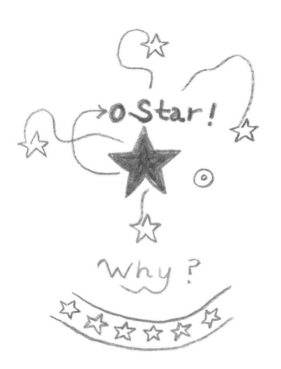

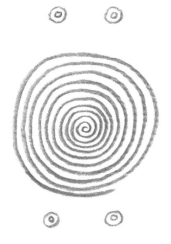

Works & Days
& the two sorts
of strife

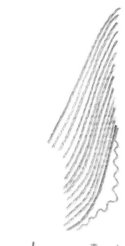

o how I loved

the Long pastures

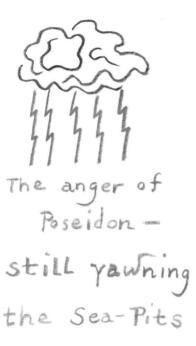

The anger of
Poseidon —

still yawning

the Sea-Pits

Pecks of walnuts 50¢
on Cemetery Hill

the year FDR
passed
into infinity

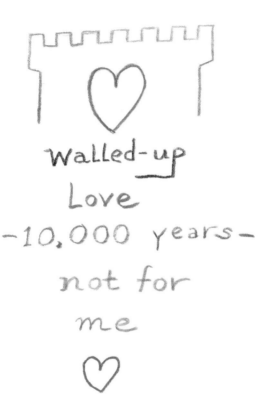

Walled-up
Love
–10,000 years–
not for
me

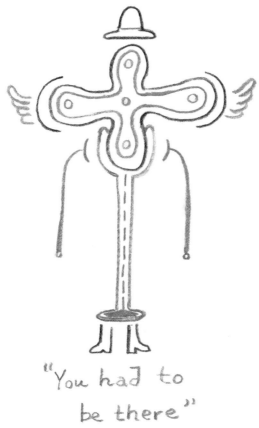

"You had to
be there"

"Wake up little Susie"
is not part of
The Bhagavad Gita
—well, unless
it's something
Like

Wake up
Big
kṛṣṇam

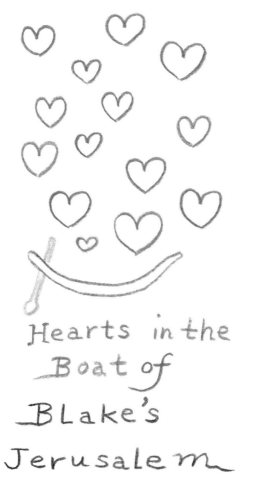

Hearts in the
Boat of
Blake's
Jerusalem

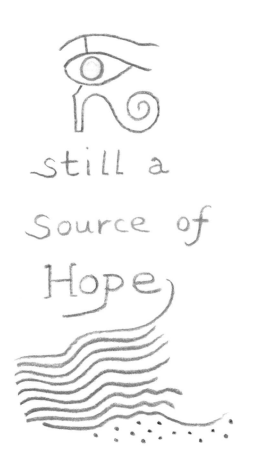

still a

Source of

Hope

Cowper's
Hare —
"old Tiney"

— dead these centuries

Yet the grief
for Tiney

flows onward

~~~~~
~~~~~
~~~~~

I wonder
what Blake did
for Lamp-Light?

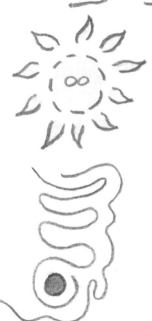

O Mollie

Mollie

Mollie

Mollie

Mollie

my ever-present

sun-boat!

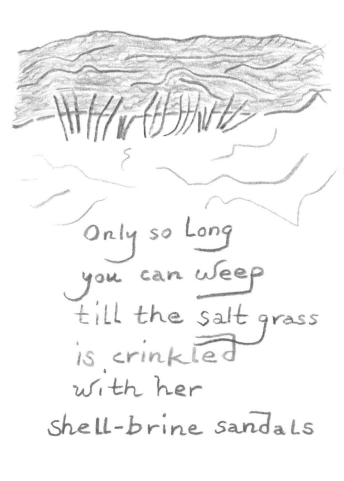

Only so long
you can weep
till the salt grass
is crinkled
with her
shell-brine sandals

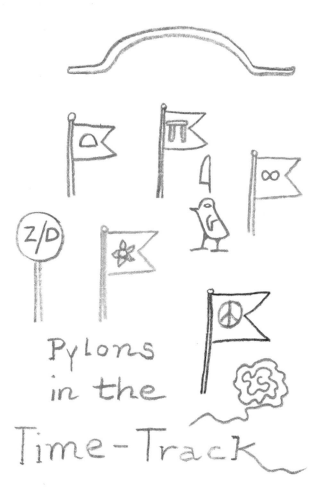

Pylons in the
in the
Time-Track

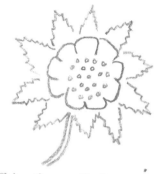

Oh how I wish the

# Time Blossom
## Would Grant ALL

# Glory

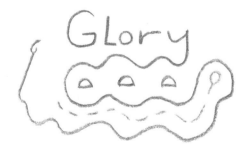

You say
It's so difficult
to say Goodbye

then "Click"

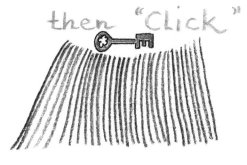

Emptiness

Spin

Measure

Cut

Sing

Thought

Meter

Melody

Ahhh.

Smile-Book of

Grace-Joy

begun

in the

Casa de Popolo
Florence
9-28-08

Edward Sanders

*A Book of Glyphs* is printed in an edition of 700 copies in paperback.

There is also a limited edition of 51 copies hand-bound in marbled  paper over boards and signed by the poet. The limited edition is accompanied by "Glyph Notes," Ed Sanders's commentary on the Glyphs; the two volumes are housed in a specially made box. Details of the limited edition, as well as a PDF of "Glyph Notes" can be found at www.granarybooks.com.

Book and cover design by Lotus + Pixel.

Printed and bound by Thomson-Shore in Dexter, Michigan.